How To Draw People : Pencil Drawings Step By Step

Pencil Drawing Ideas for Absolute Beginners

By Gala Publication

Published By:

Gala Publication

ISBN-13: 978-1515199632
ISBN-10: 1515199630

©Copyright 2015 – Gala Publication

ALL RIGHTS RESERVED. No part of this publication may be reproduced or transmitted in any form whatsoever, electronic, or mechanical, including photocopying, recording, or by any informational storage or retrieval system without express written, dated and signed permission from the author.

Table of Contents

Learn To Draw People 10 Characters:
 Learn To Draw Anime Boy
 Learn To Draw Baby..
 Learn To Draw Cartoon Princess
 Learn To Draw Chibi...
 Learn To Draw Cowgirl
 Learn To Draw Cute Girl....................................
 Learn To Draw Dino Kid
 Learn To Draw Emo ..
 Learn To Draw Gothic Boy Character...............
 Learn To Baby Scene Girl

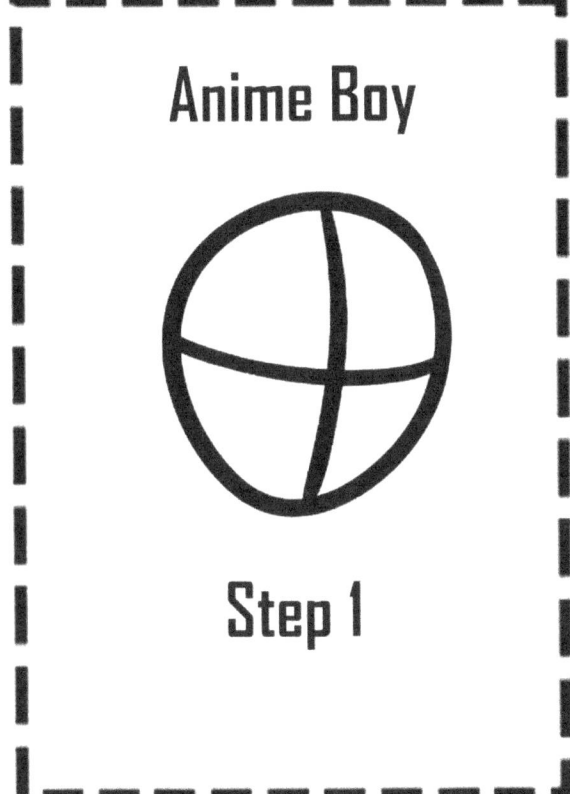

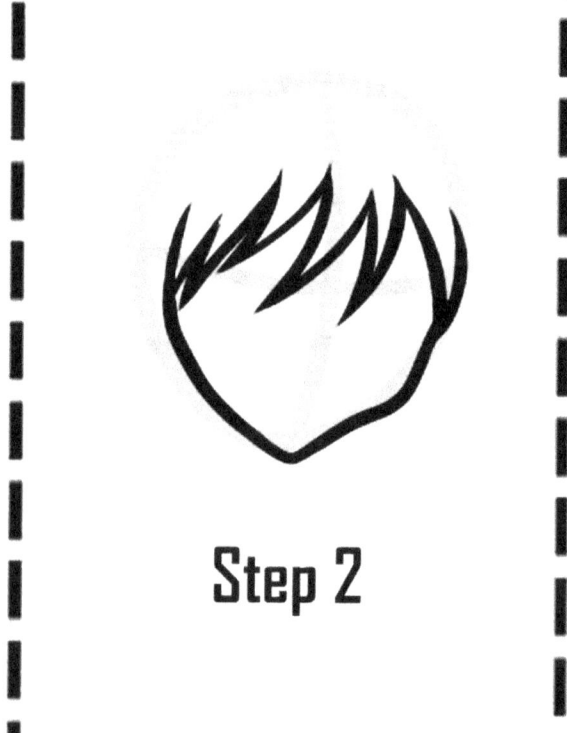
Step 2

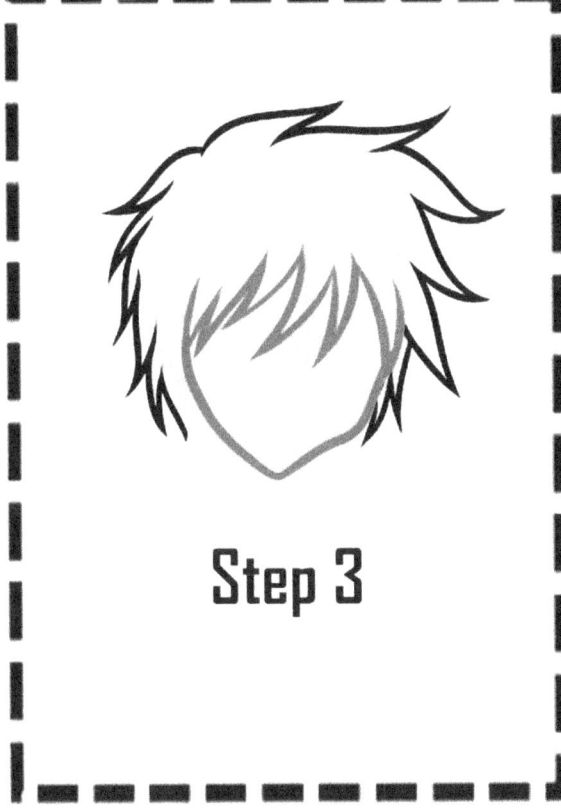

Step 3

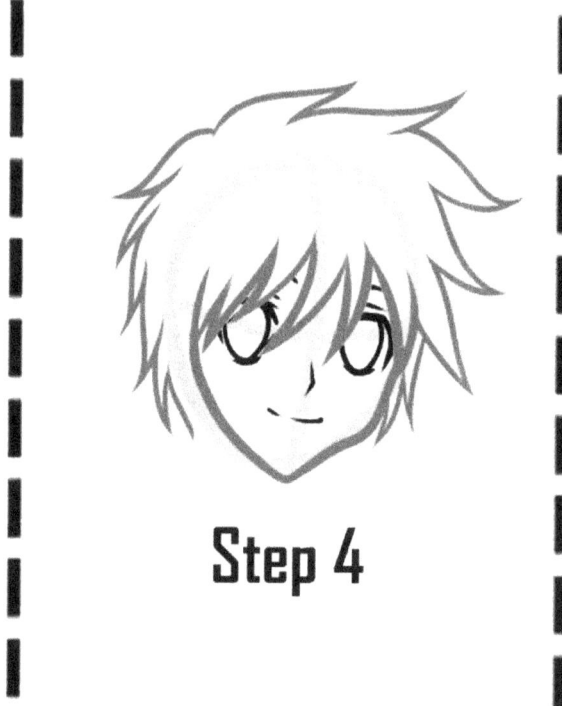

Step 4

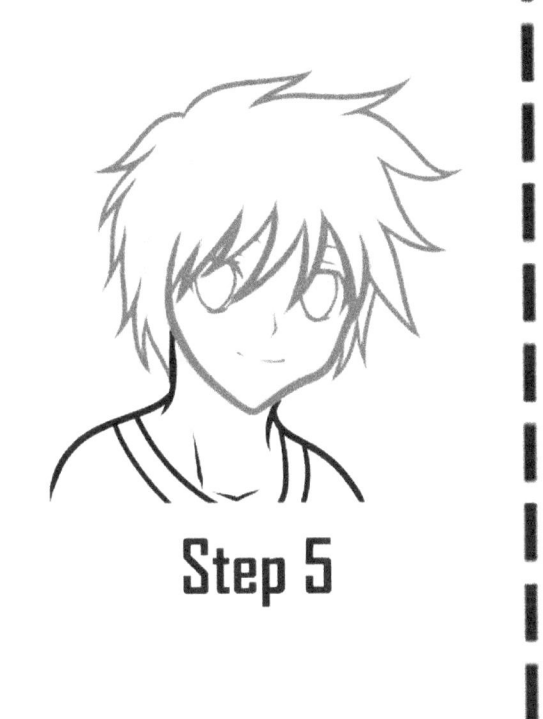
Step 5

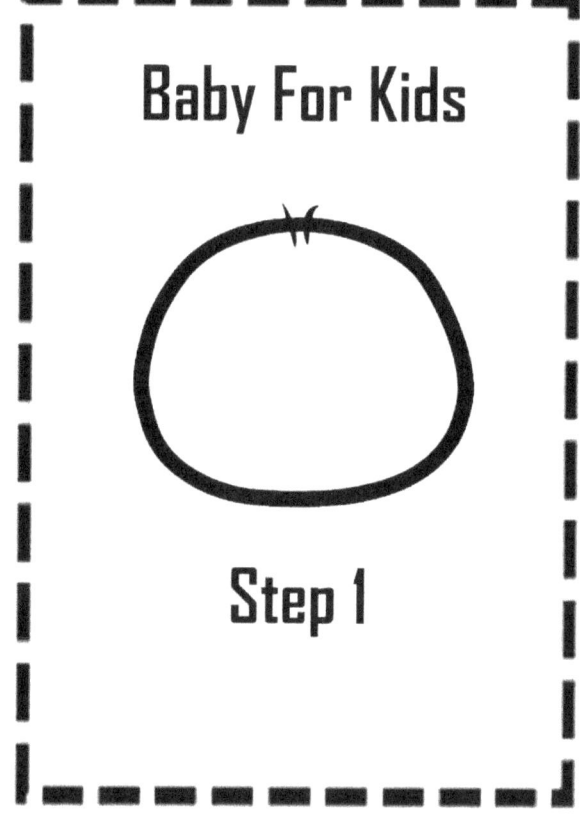

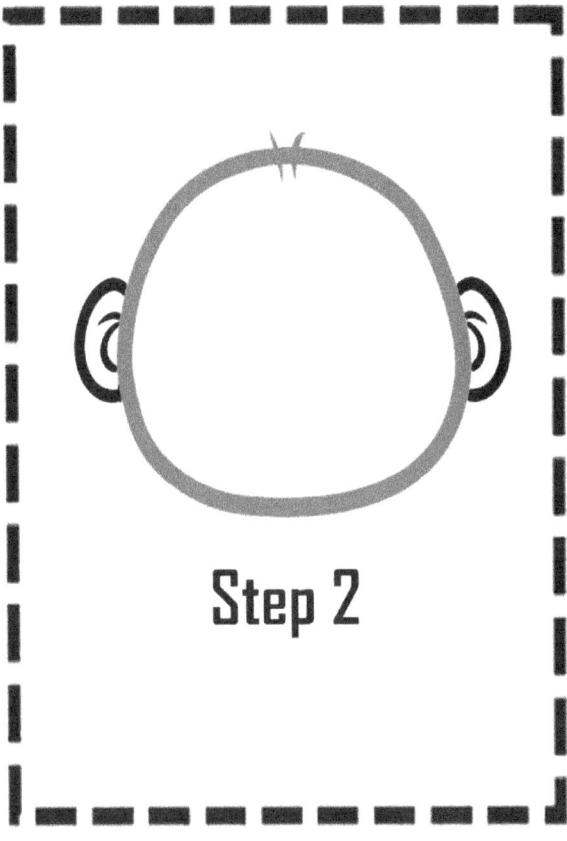

Step 2

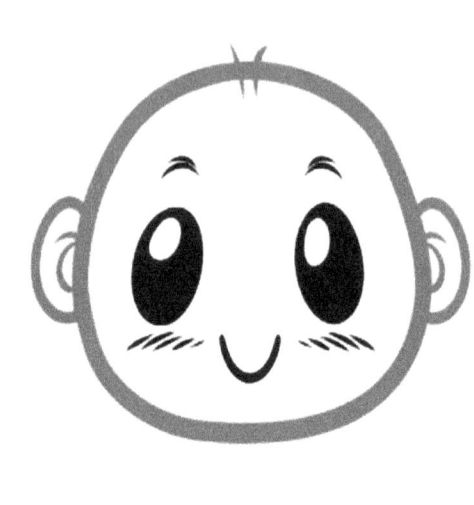

Step 3

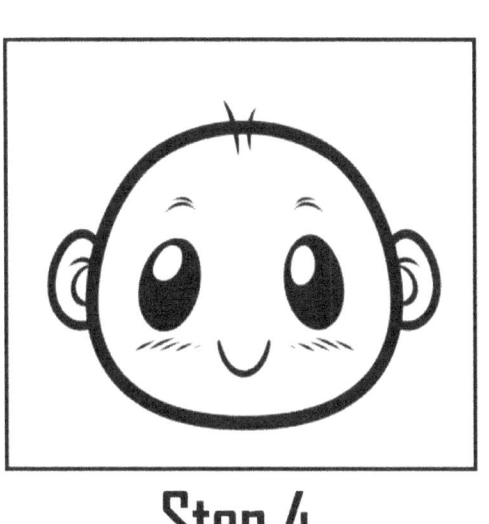

Step 4

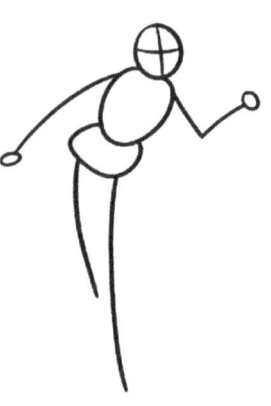

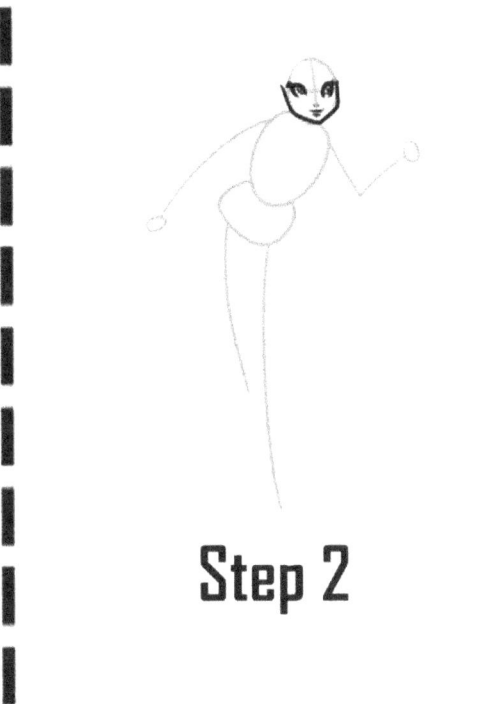

Step 2

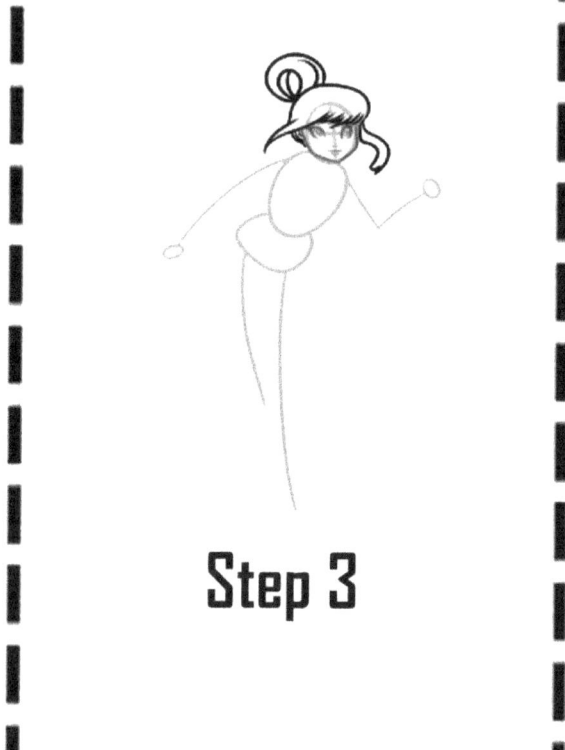

Step 3

Step 4

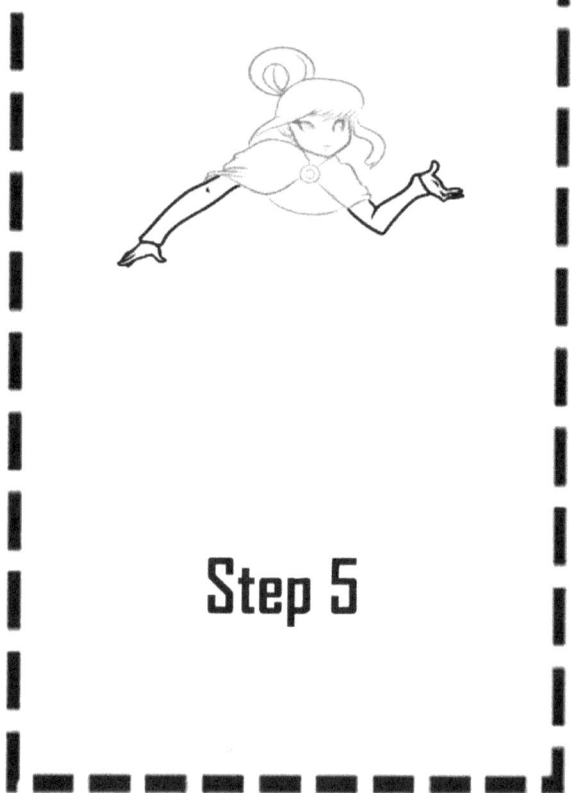

Step 5

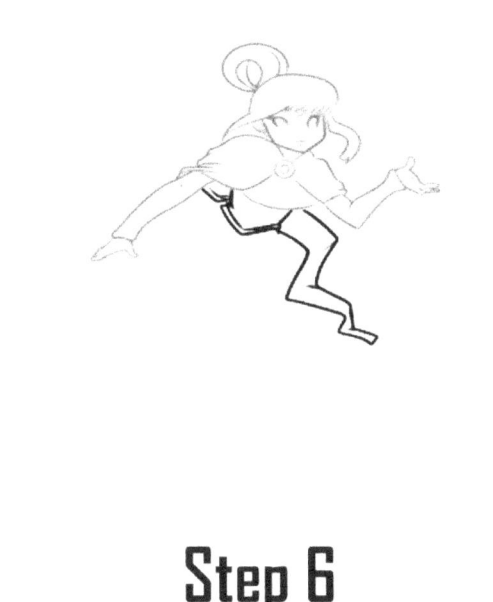

Step 6

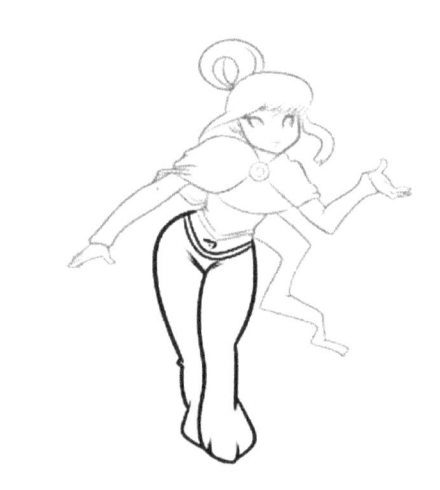

Step 7

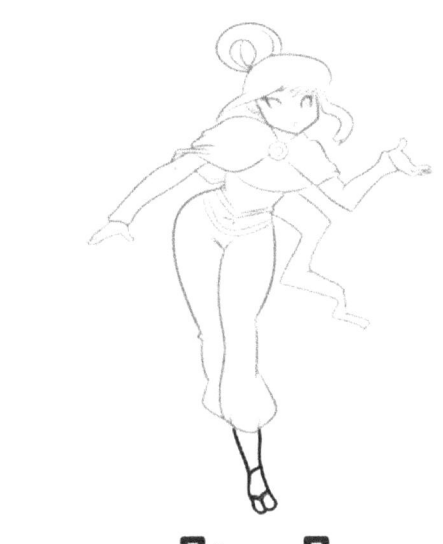

Step 8

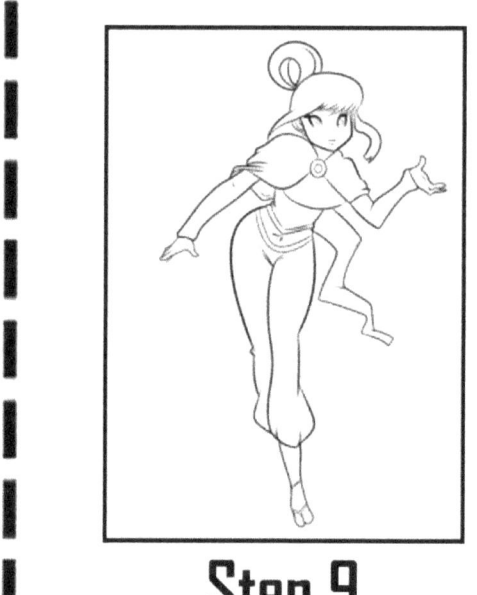

Step 9

Chibi

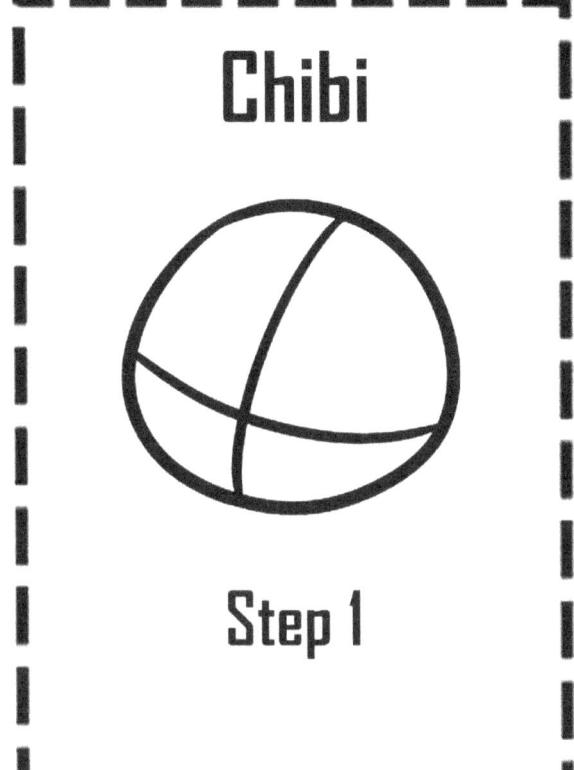

Step 1

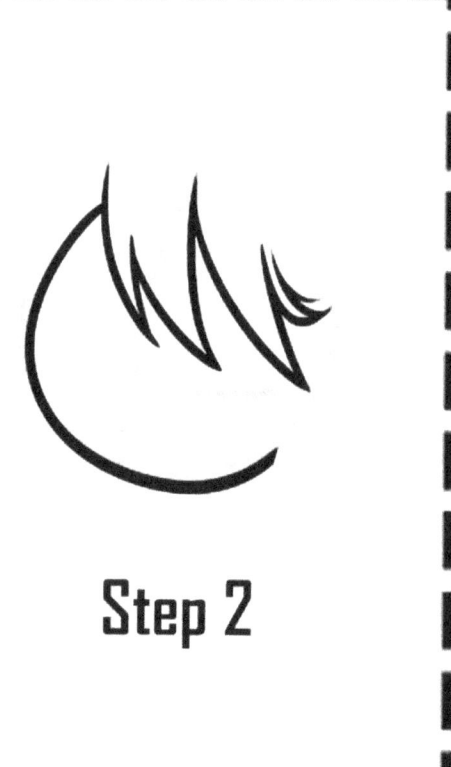

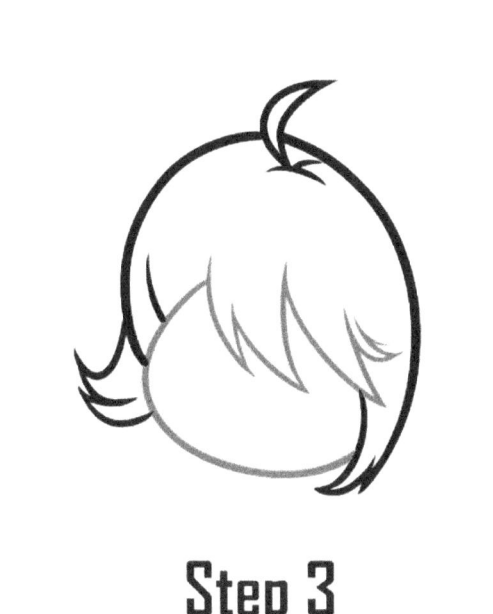

Step 3

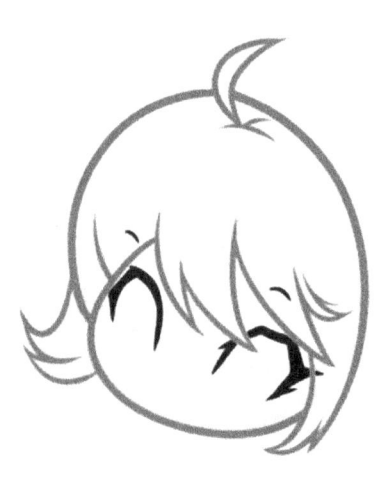

Step 4

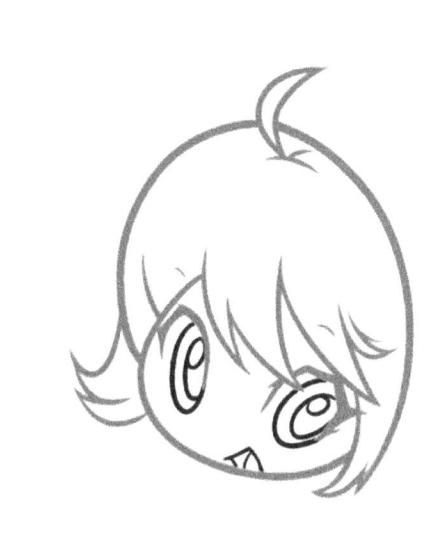

Step 5

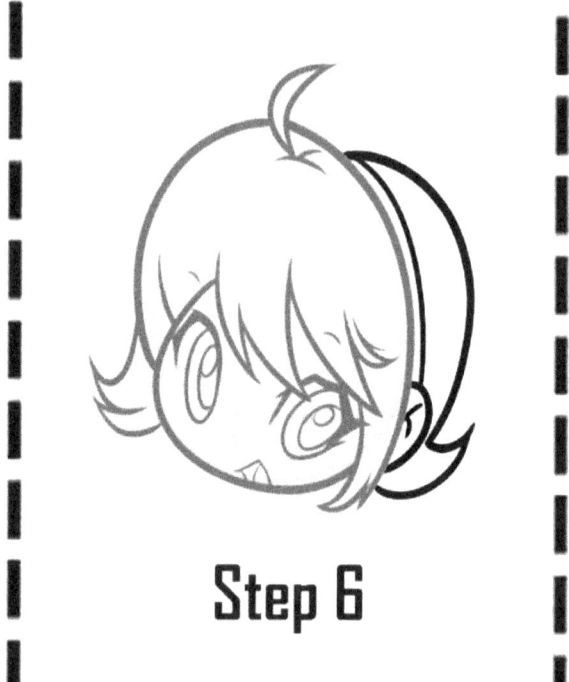

Step 6

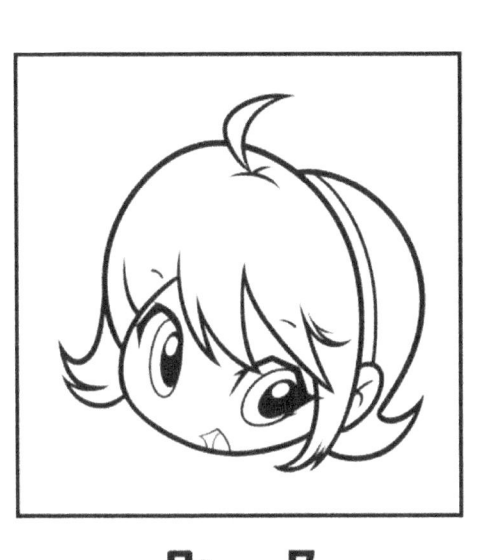

Step 7

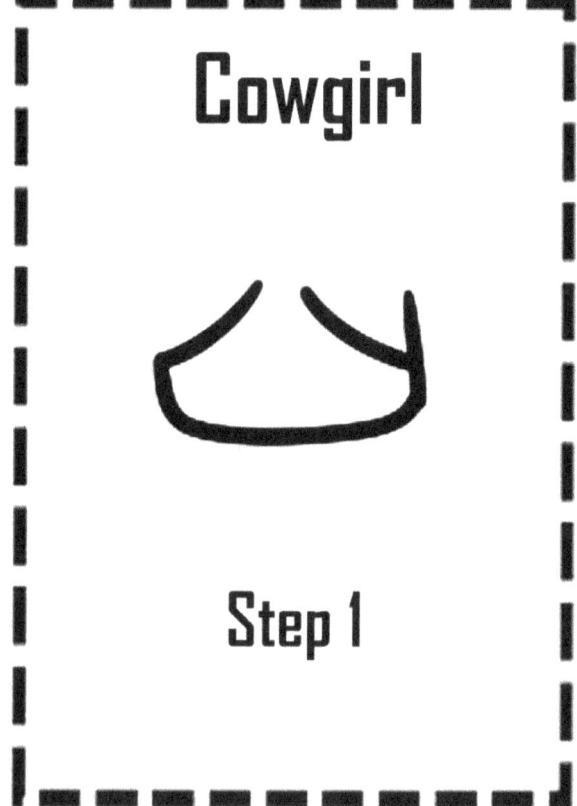

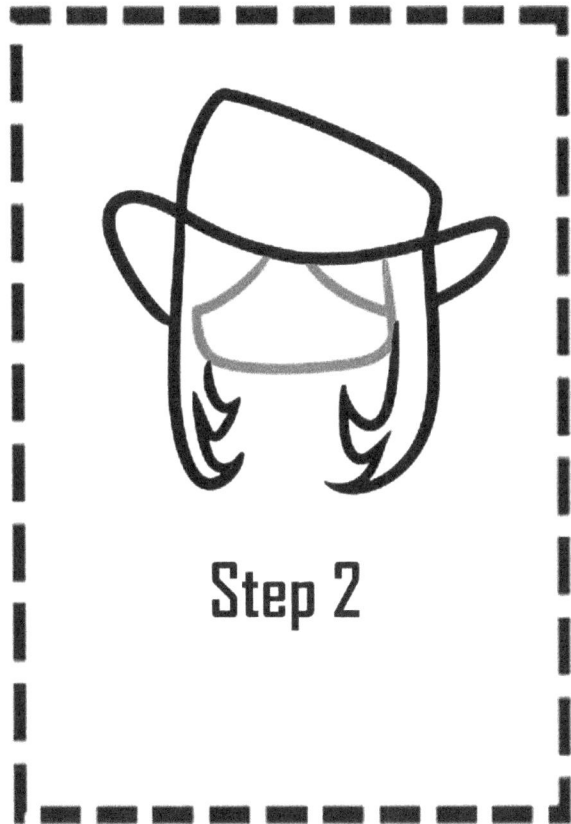

Step 2

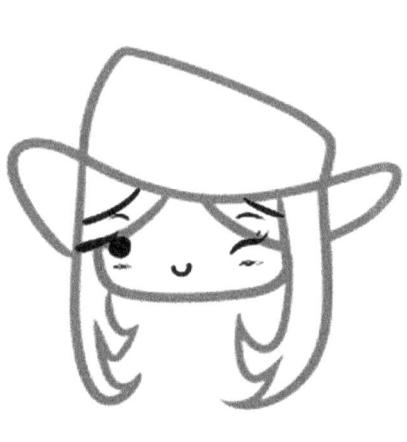

Step 3

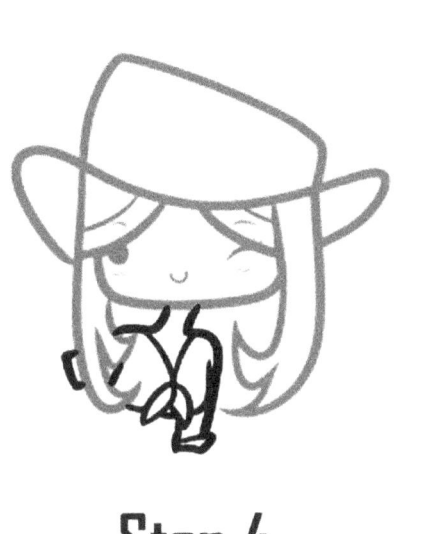

Step 4

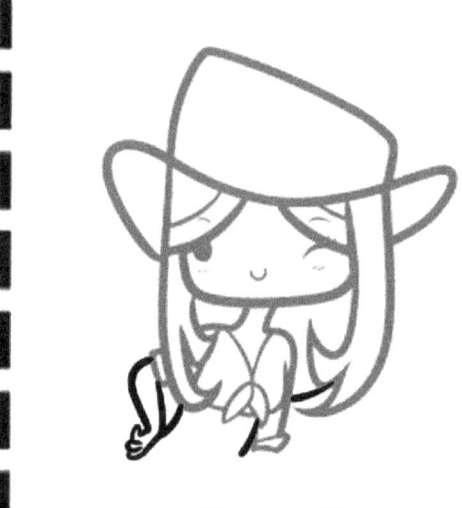

Step 5

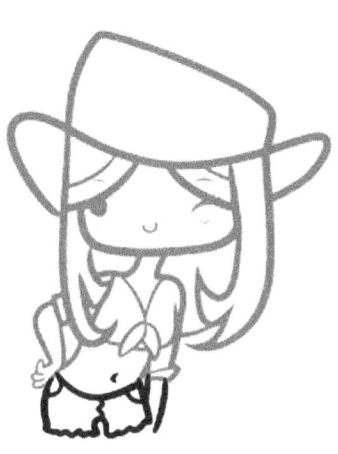

Step 6

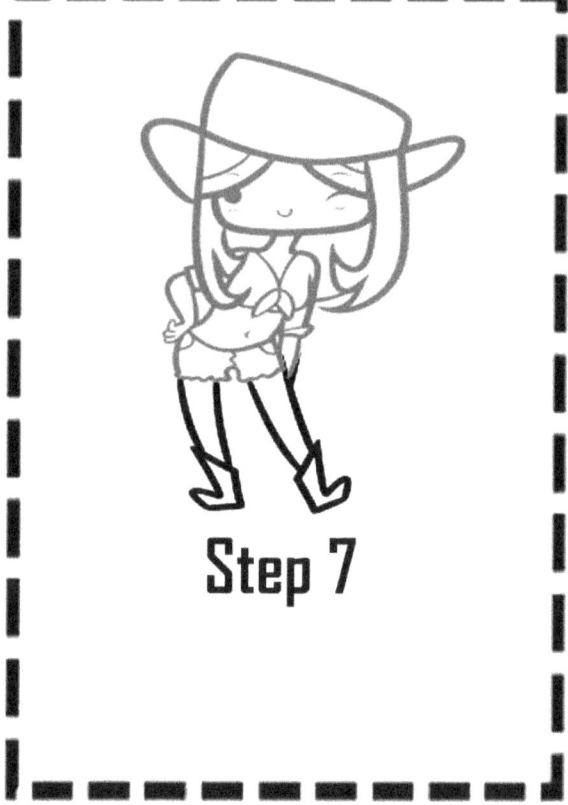

Step 7

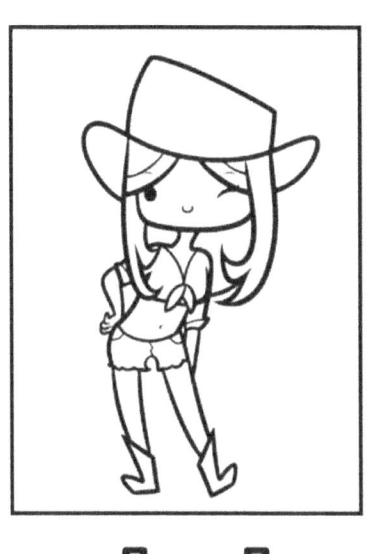

Step 8

Cute Girl

Step 1

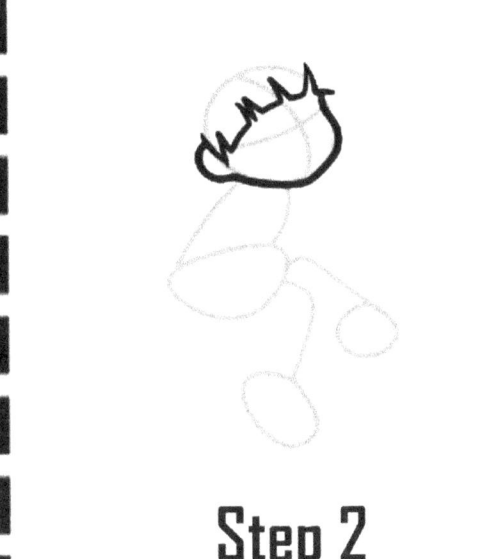

Step 2

Step 3

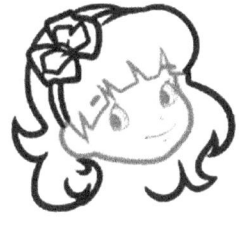

Step 4

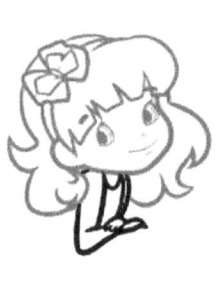

Step 5

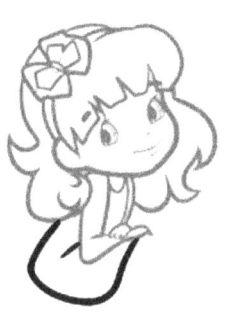

Step 6

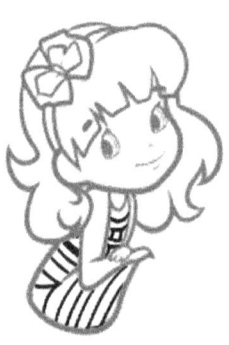

Step 7

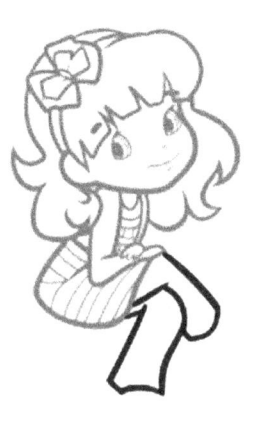

Step 8

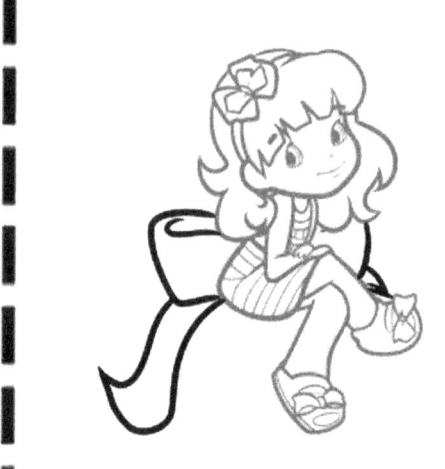

Step 9

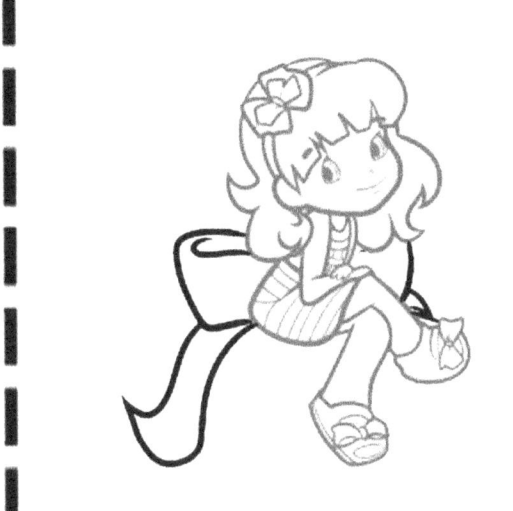

Step 10

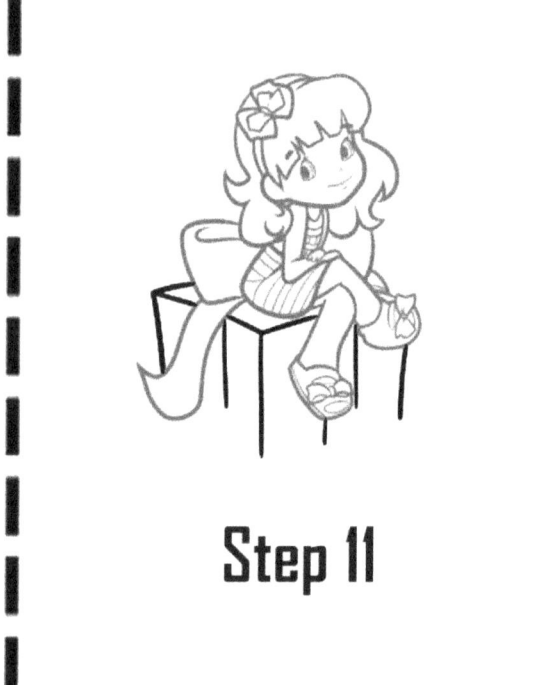

Step 11

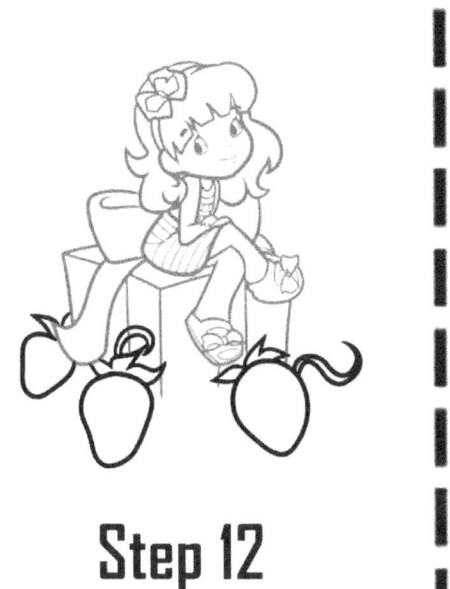

Step 12

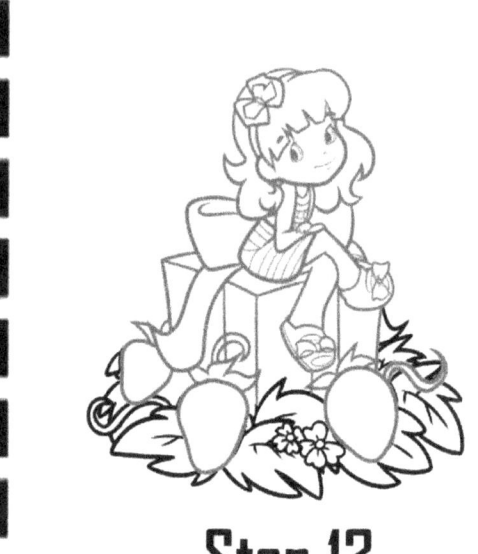

Step 13

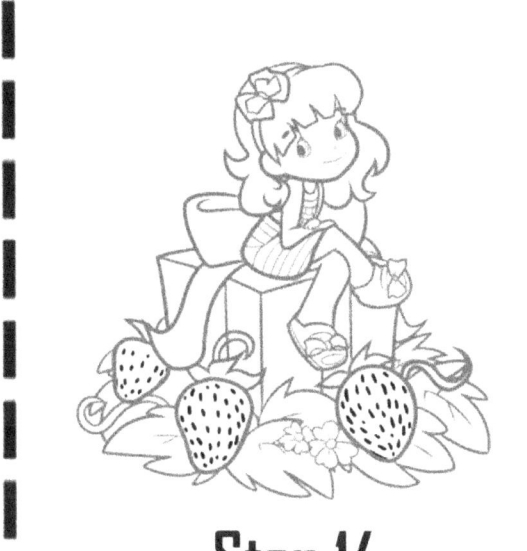

Step 14

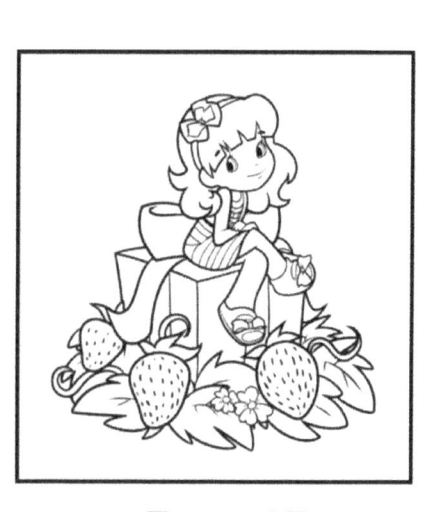

Step 15

Dino Kid

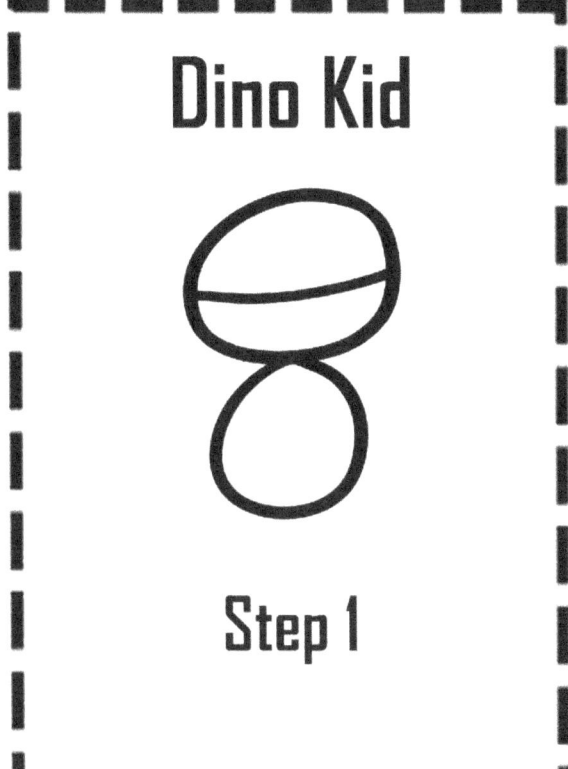

Step 1

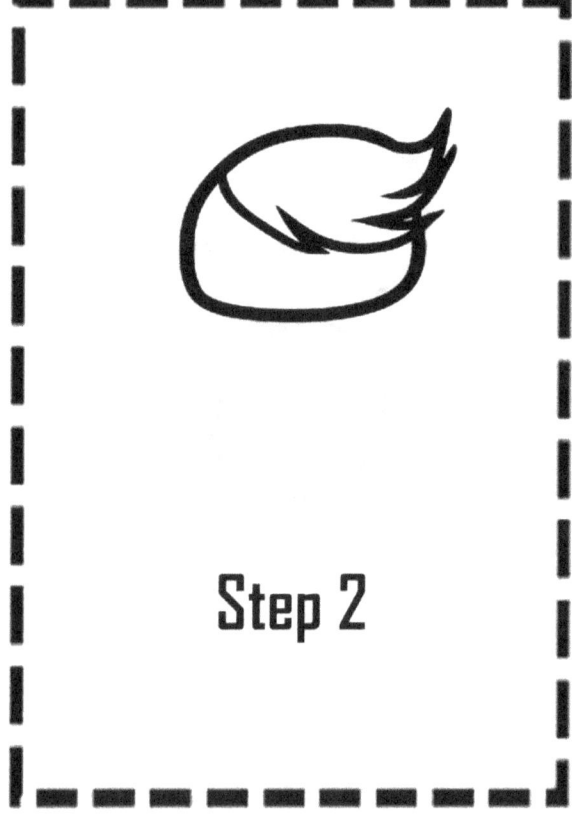

Step 2

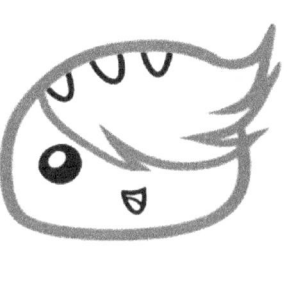

Step 3

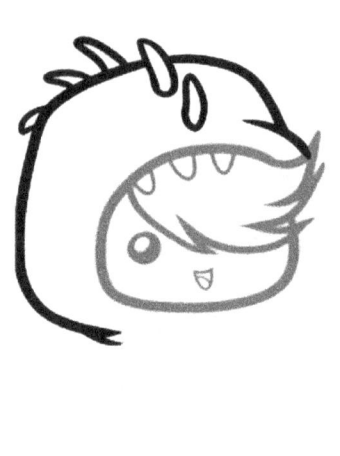

Step 4

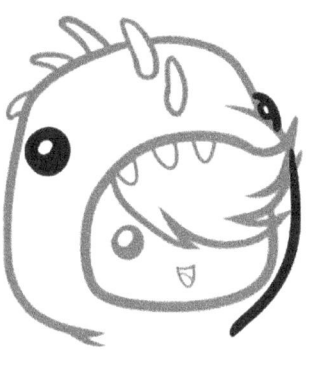

Step 5

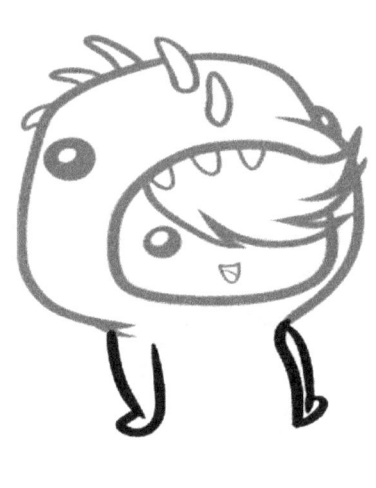

Step 6

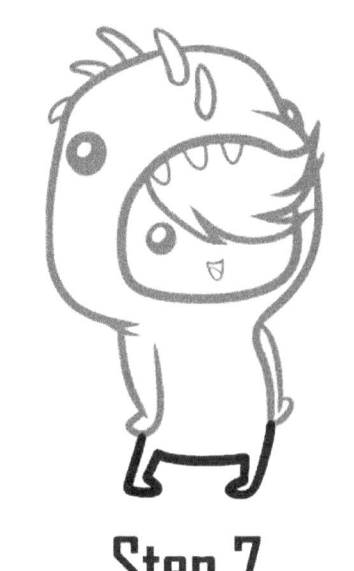

Step 7

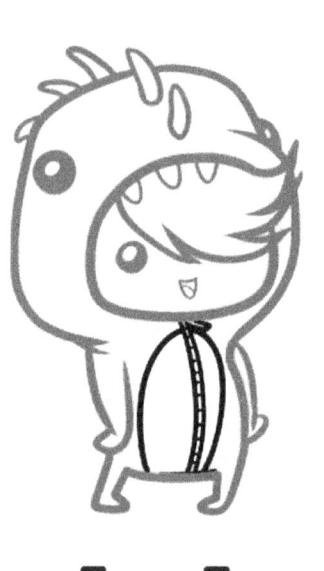

Step 8

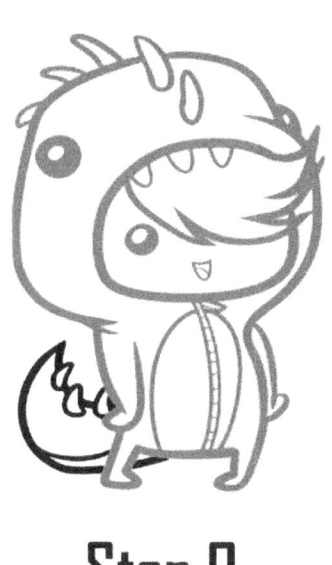

Step 9

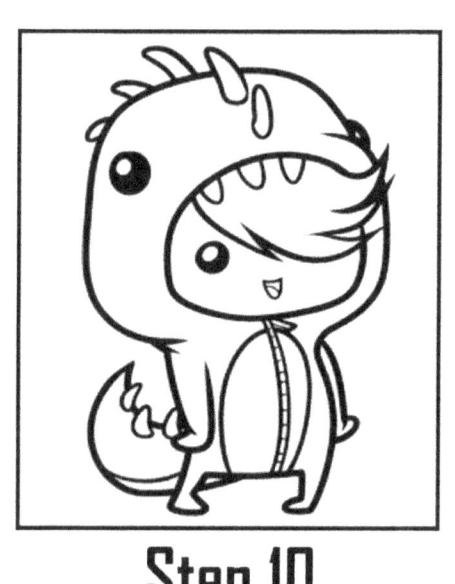

Step 10

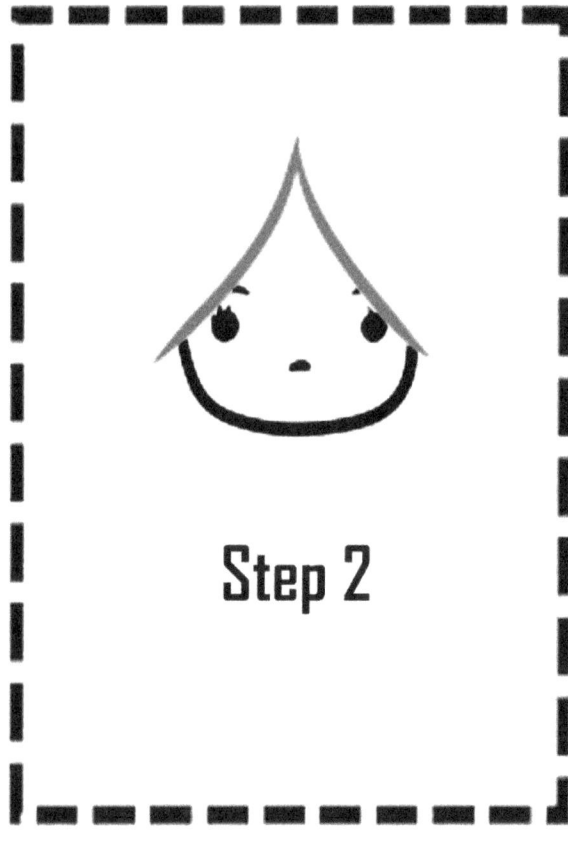

Step 2

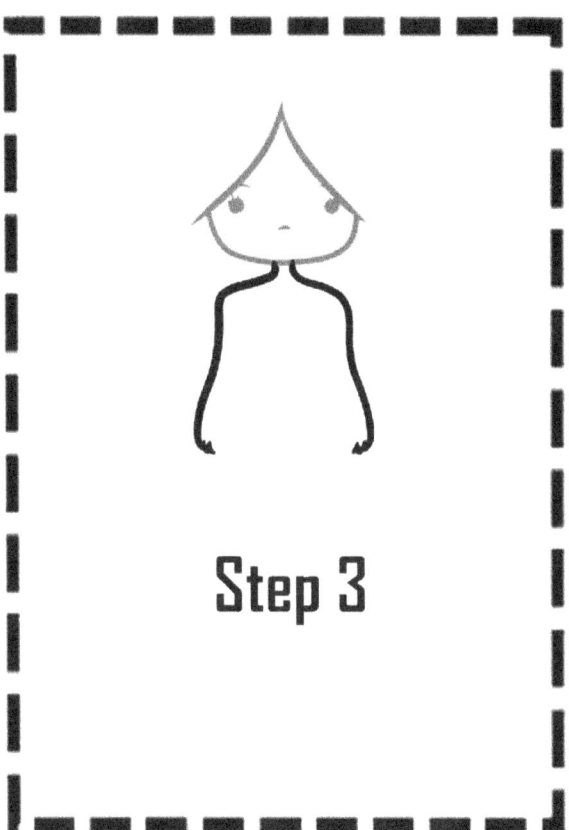

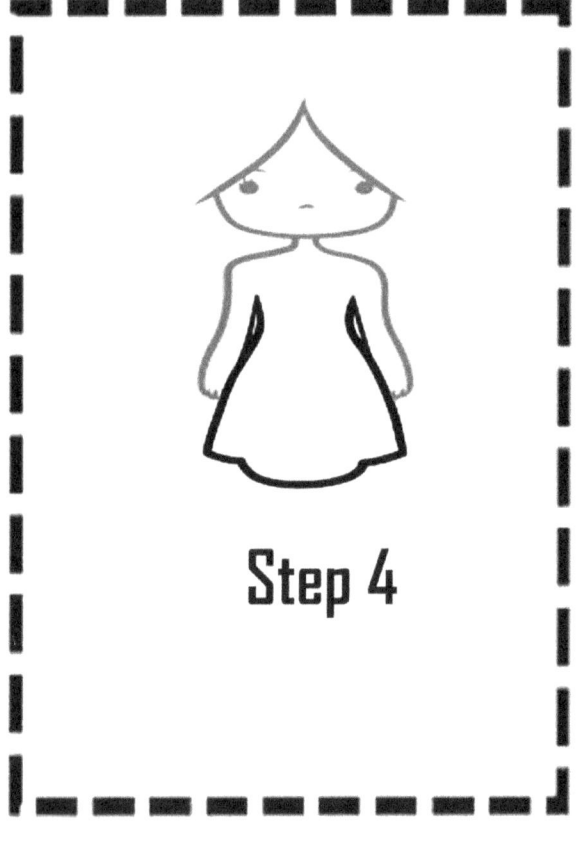

Step 4

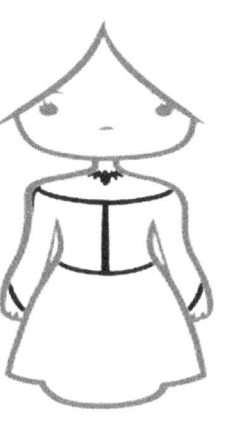

Step 5

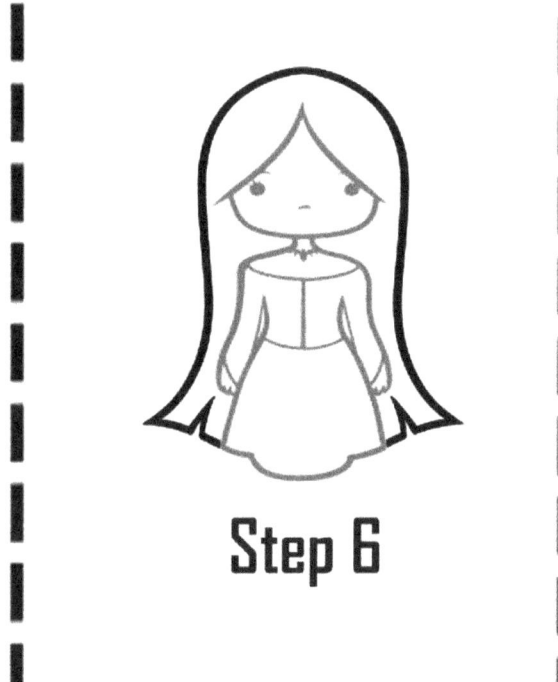

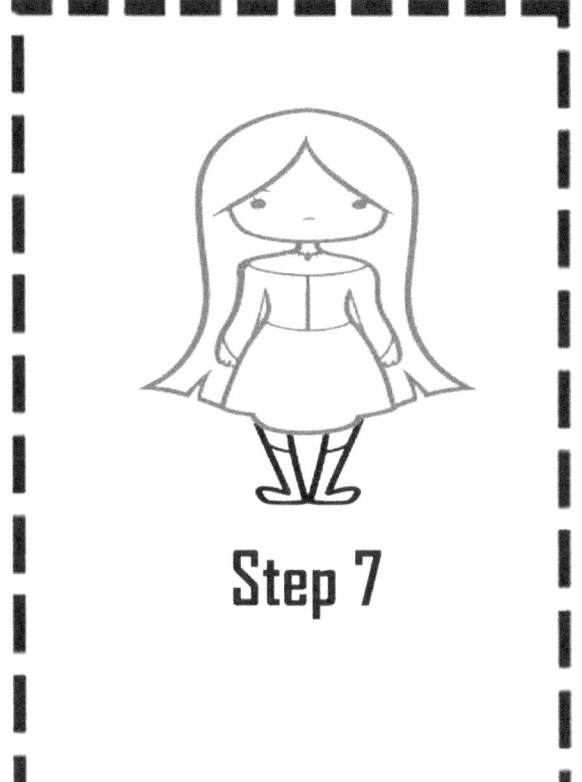

Step 7

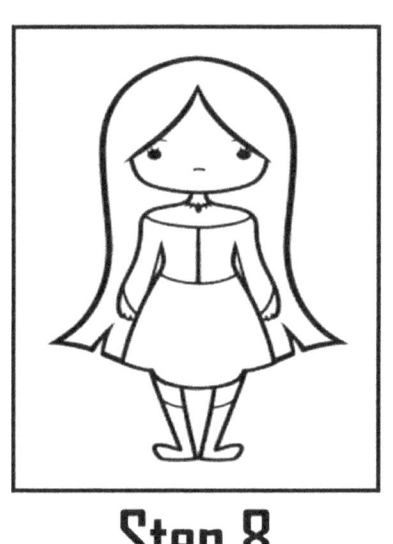

Step 8

Gothic Boy Character

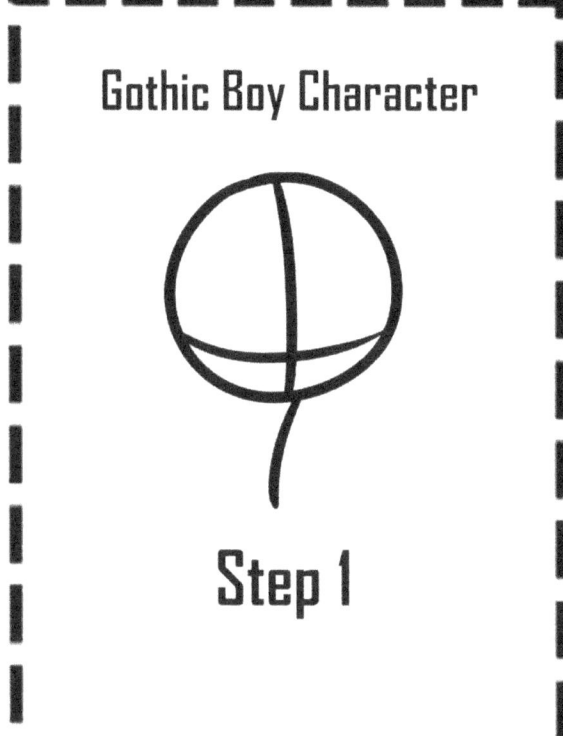

Step 1

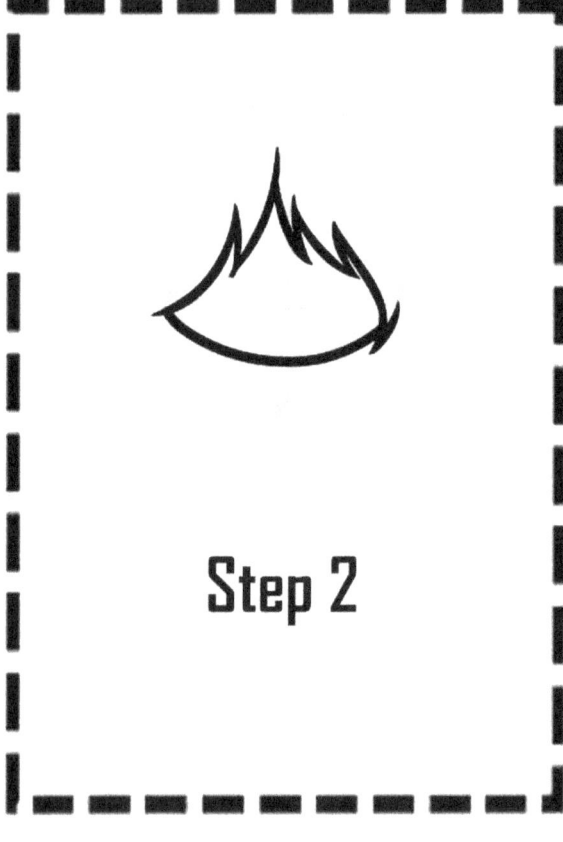

Step 2

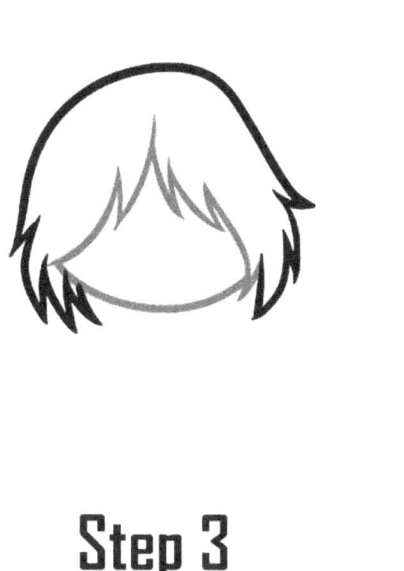

Step 3

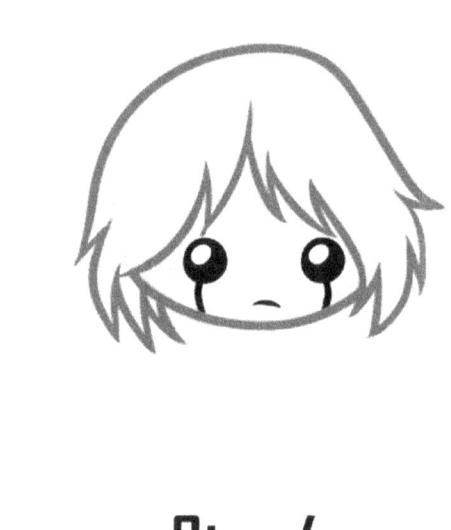

Step 4

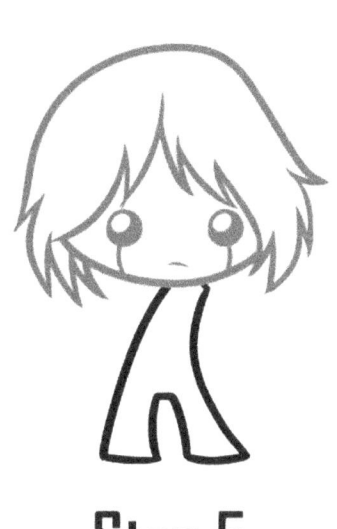

Step 5

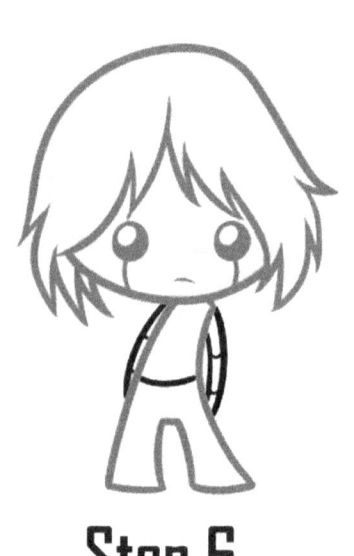

Step 6

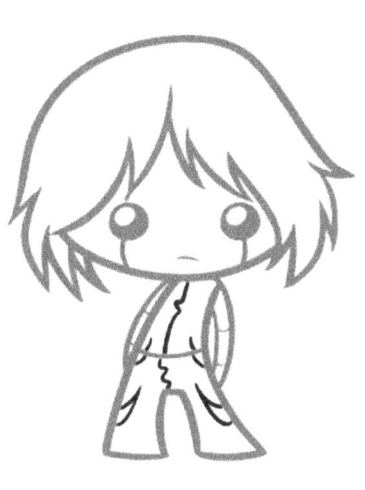

Step 7

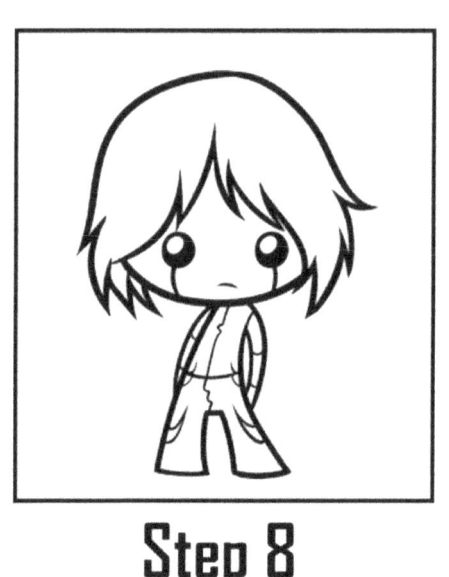

Step 8

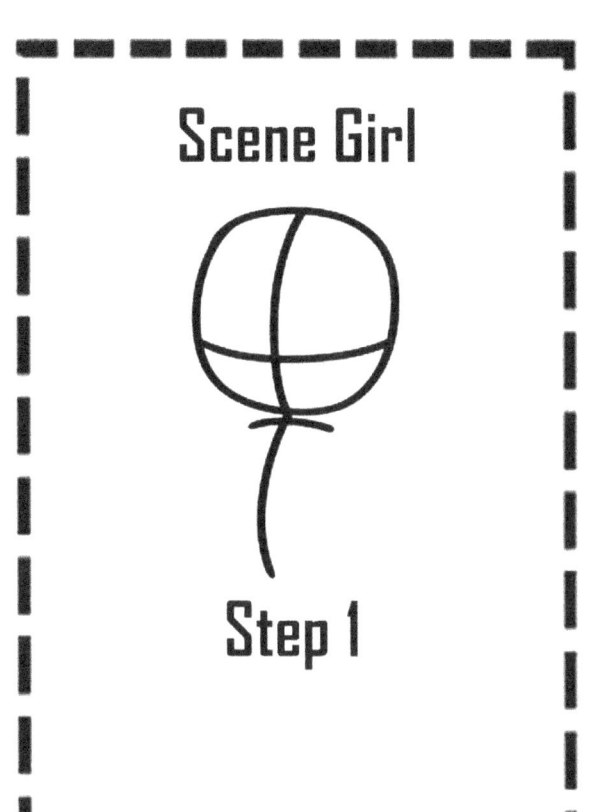

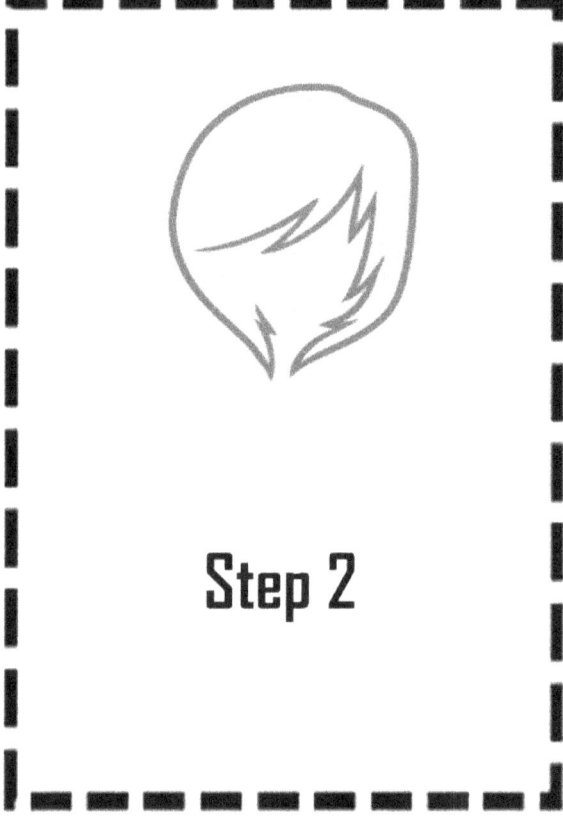

Step 2

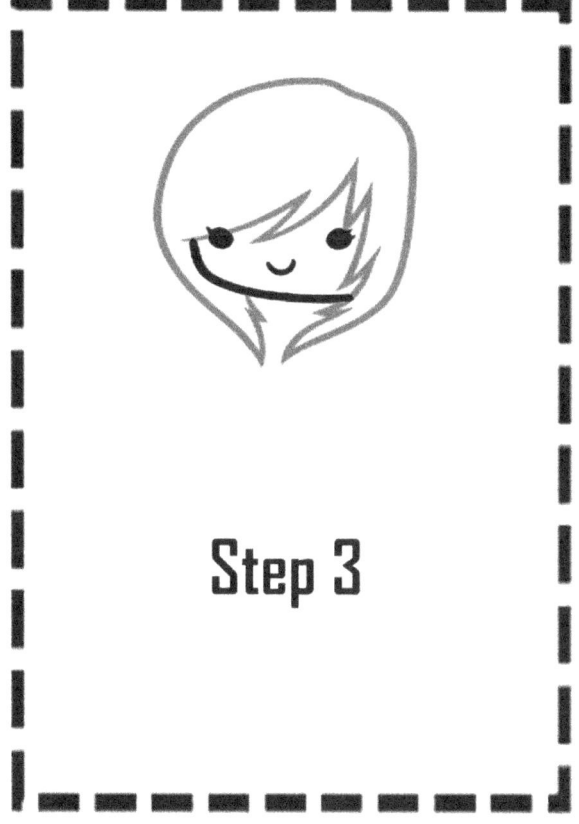

Step 3

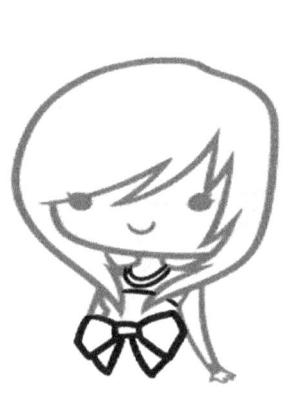

Step 4

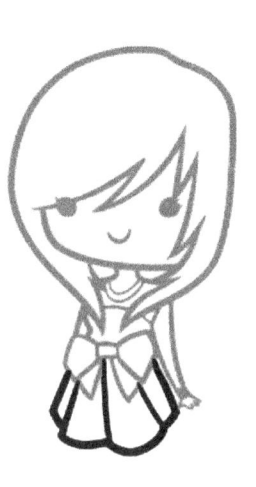

Step 5

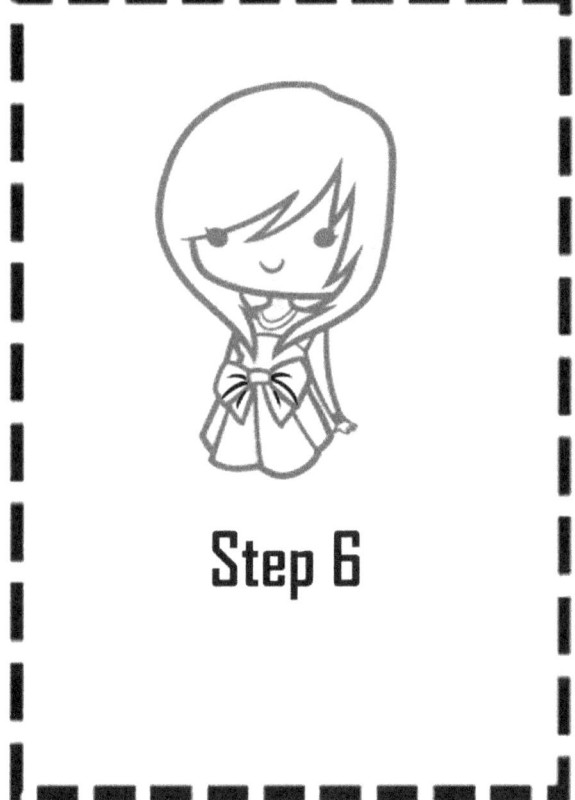

Step 6

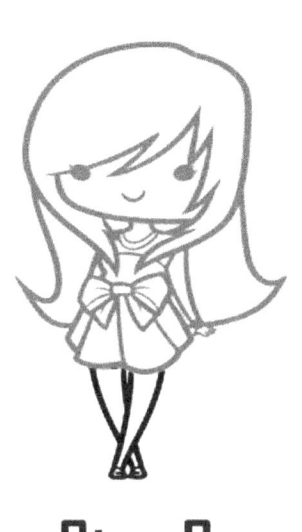

Step 8

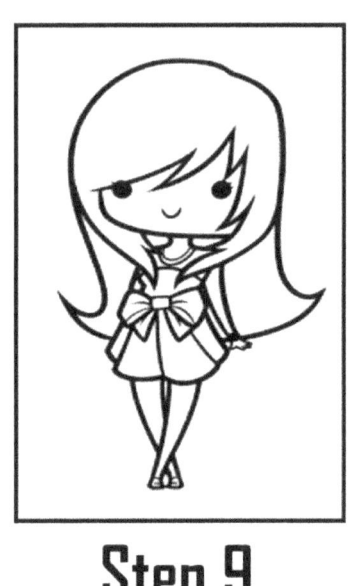

Step 9

LL RIGHTS RESERVED. No part of this publication may be reproduced or transmitted in any form whatsoever, electronic, or mechanical, including photocopying, recording, or by any informational storage or retrieval system without express written, dated and signed permission from the author.

www.ingramcontent.com/pod-product-compliance
Lightning Source LLC
Chambersburg PA
CBHW072308200526
45168CB00014B/894